I PREDICT A RIOT

Jane Stockdale

Koenig Books

TO MISS RIED + ALL AT
BANCHORY ACADEMY ART DEPT.

HOPE YOU LIKE
MY LITTLE BOOK

CHEERS!

x

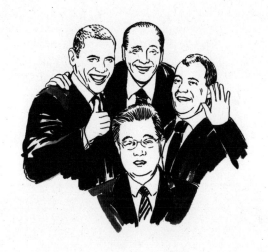

The United Kingdom is honoured to
chair the group of twenty in 2009

'If a butterfly flaps its wings in Beijing,
it can change the weather in Florida.'

01.04.09

FINANCIAL FOOLS DAY

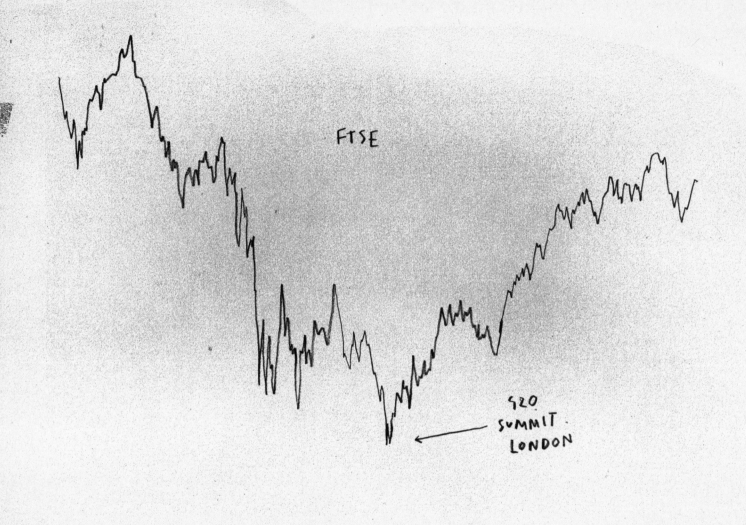

FTSE

G20
SUMMIT
LONDON

THE G20

In 2008/2009's global financial collapse we saw how interconnected the world is. The news flashes said it all - sub-prime mortgages, toxic-debt, global recession, mass redundancies, stock market crashes - scary stuff. It can be easy to be ambivalent about politics but the credit crunch affected us all. The economic crash became the big news story of 2009 because it had an impact on everyone - it cost money, pensions, homes, businesses and jobs.

After decades of easy credit when capitalism had a free reign, the financial markets collapsed. In a desperate bid to kick-start the economy hundreds of billions of pounds of tax-payer's money was pumped back into the economy and to bail out the banks.

As global leaders including Brown, Obama, Medvedev, Hu Jintao, Merkel, Sarkozy and Berlusconi gathered in London on the world stage to negotiate, debate and decide what to do, so too did thousands of protesters. The G20 in London became the focus of protests across the city over different issues ranging from the economic crisis, anger at the banking system and bonuses, the war on terror and climate change.

As the British media threatened 'a summer of rage', 16,000 police were deployed to control protests planned at key locations across London.

Here's what happened outside the Bank of England...

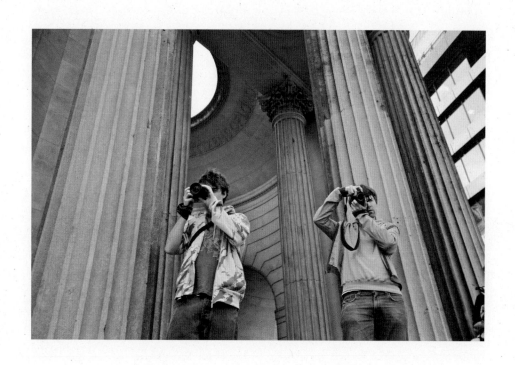

The day began peacefully as thousands of protesters marched from different locations across London to gather outside the Bank of England. Hyped as 'Meltdown in the City', workers were encouraged to dress down and postpone meetings. Many chose to work from home.

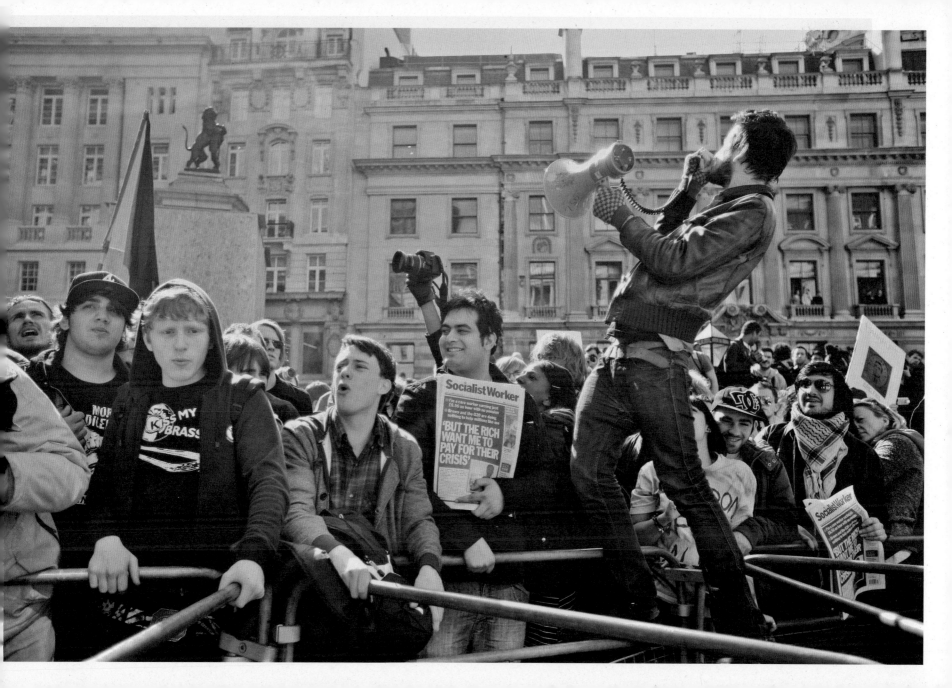

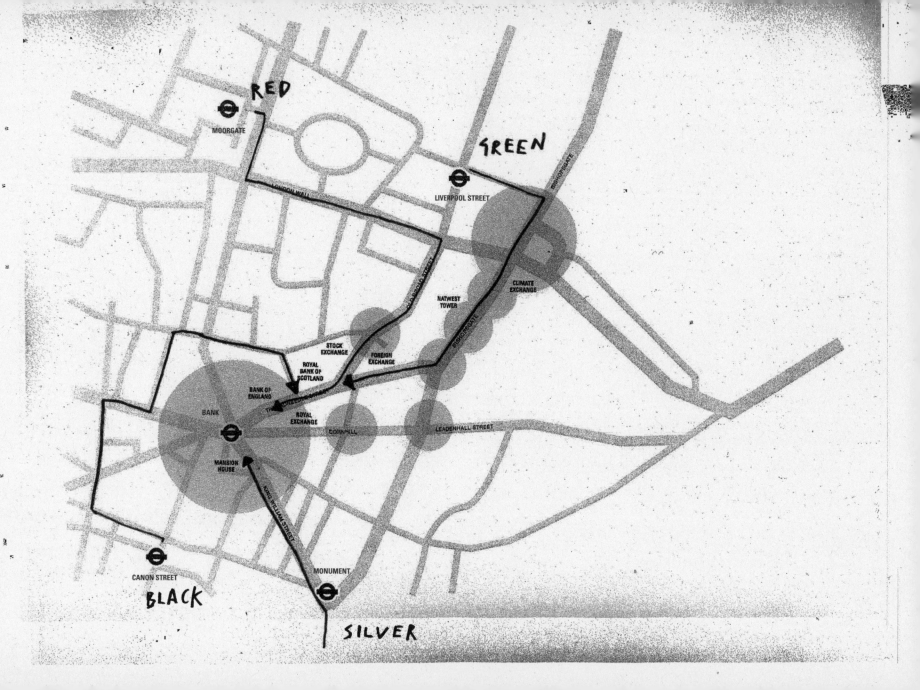

G20 MELTDOWN

11.25

4 planned marches
left from different
locations across London
each led by one of
the 'Four Horsemen
of the Apocalypse.'

The red horse against
war departed from
Moorgate station;

The green horse against
climate change from
Liverpool Street;

The silver horse against
financial crime from
London Bridge;

The black horse against
land closures from
Cannon Street.

11.53

Protesters began
to arrive outside
the Bank of England.

12.52

Police cordoned off
thousands of protesters
outside the Bank of
England. This led to
violent clashes with
police as people tried
to force their way out.

13.45

The windows of a branch
of the Royal Bank of
Scotland were smashed
by a group of protesters
who were surrounded
by photographers.

Around 19.20

Bystander Ian Tomlinson
is pushed to the ground
by a police officer while
walking on his way home
along Royal Exchange
passage and later dies,
raising questions about
police brutality.

20.00

The police 'kettled' in
over 5,000 people inside
a sealed off cordon for
up to 7 hours without
food or water.

Protesters were
eventually allowed to
leave but were asked
for their names and
addresses and required
to have their photograph
taken by police.

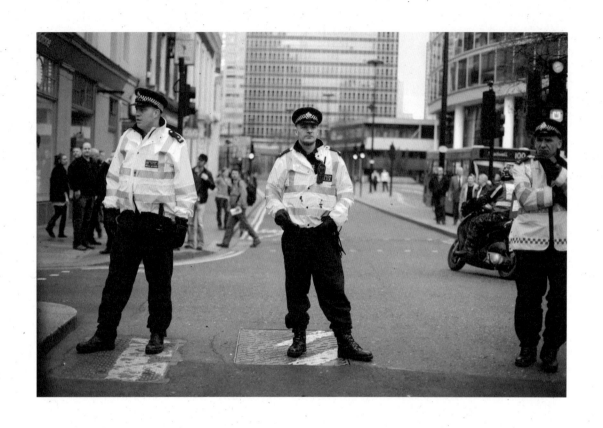

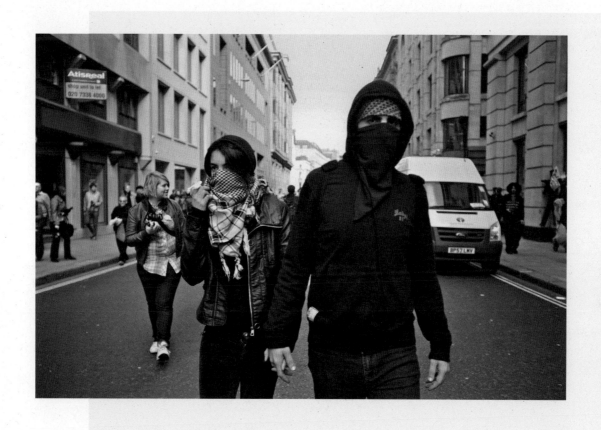

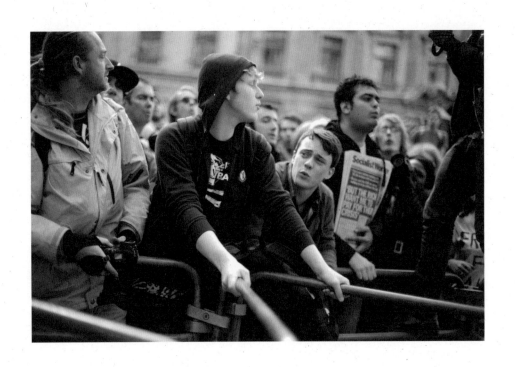

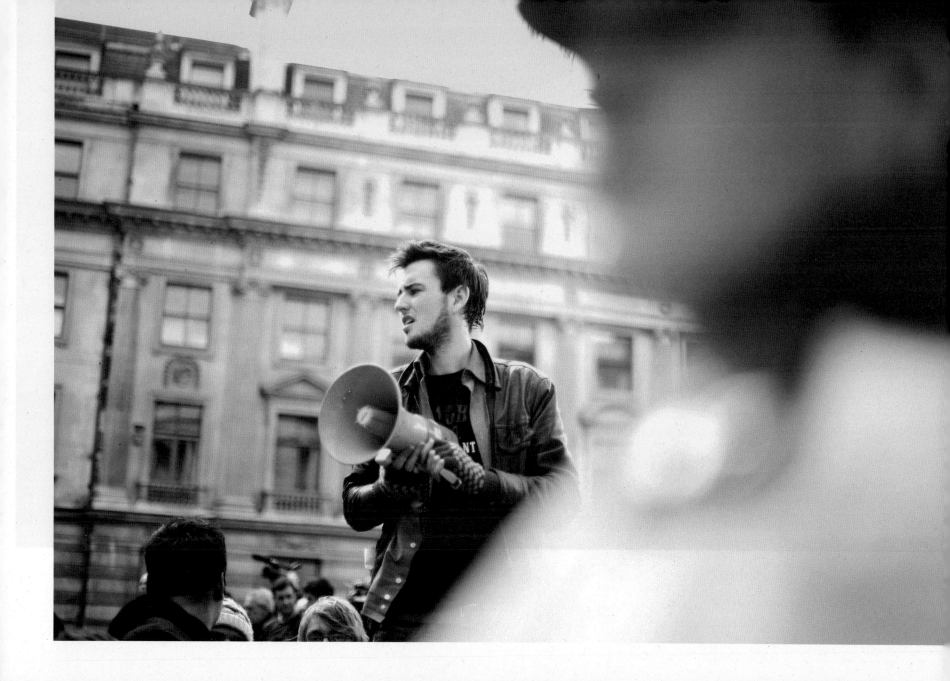

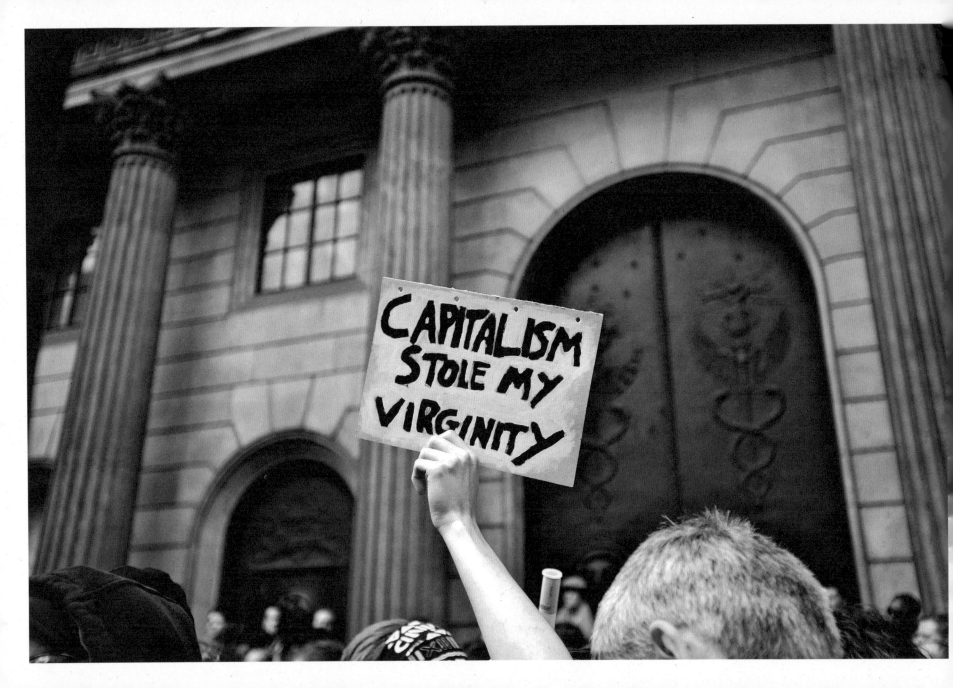

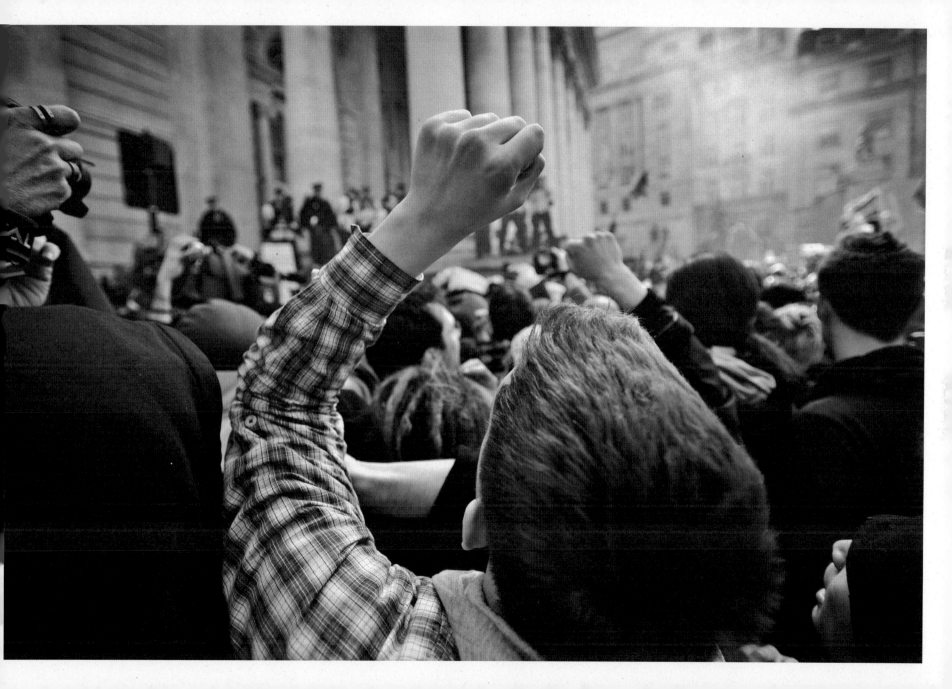

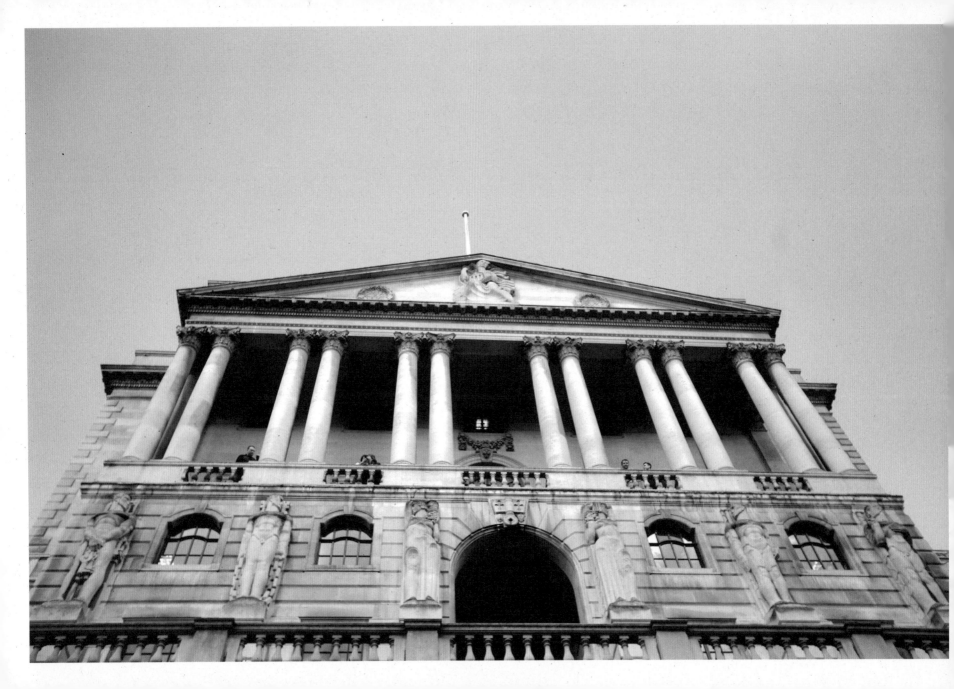

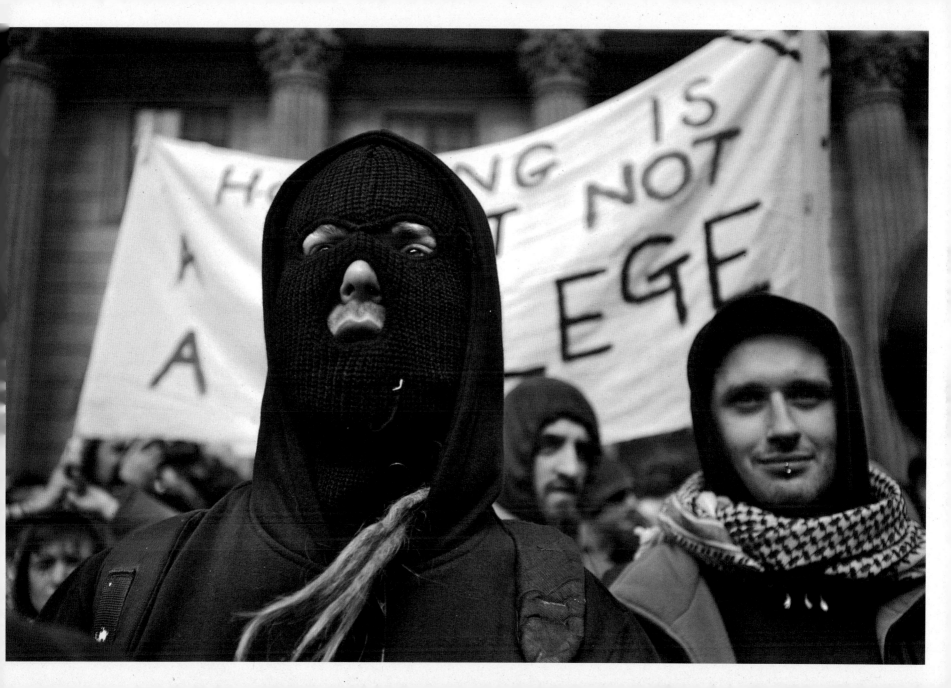

HEADS WE WIN.

‘TAILS YOU LOSE.

People were angry at the 'heads we win, tails you lose'
attitude of the government bailing out the banks to
the tune of billions of pounds of taxpayers money.

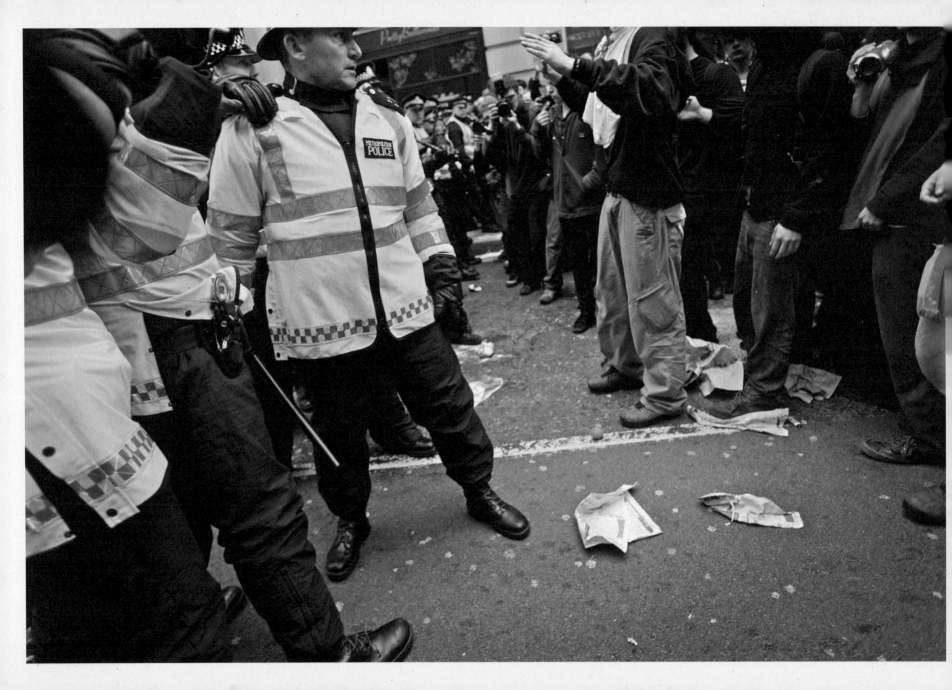

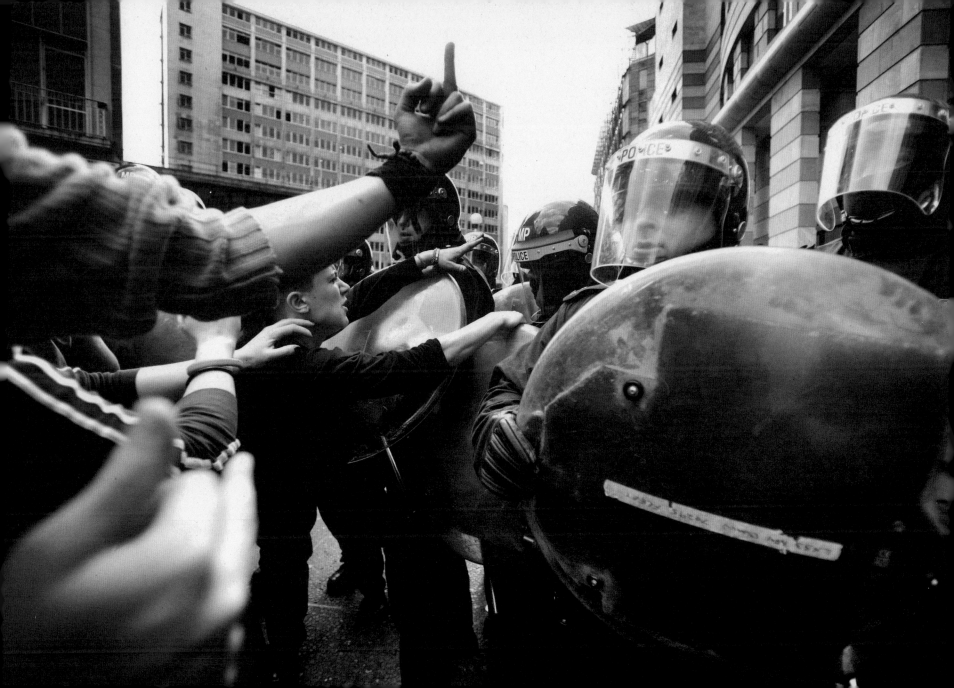

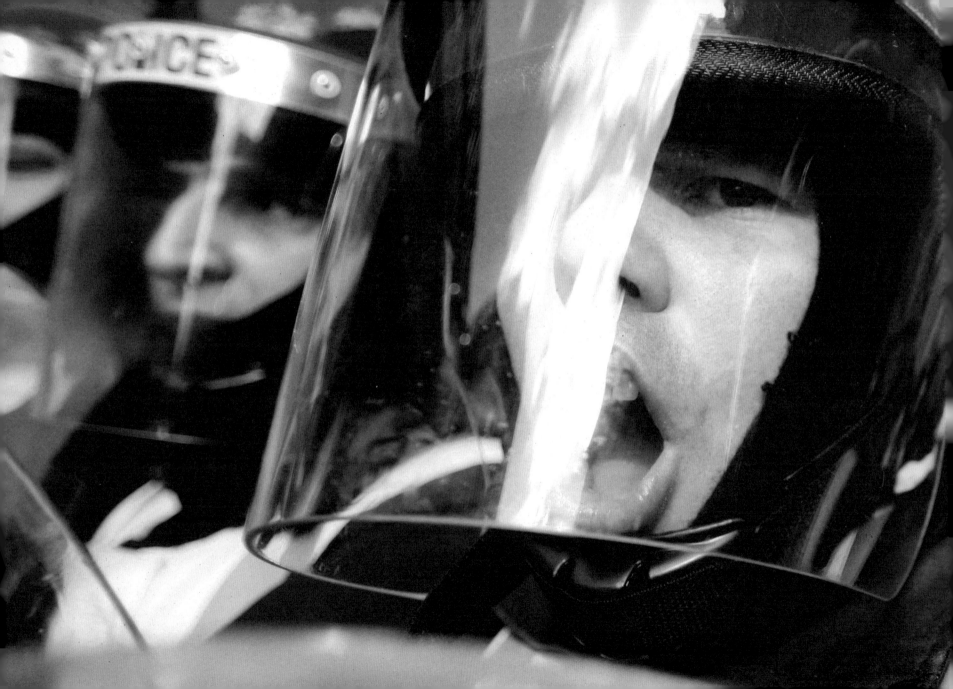

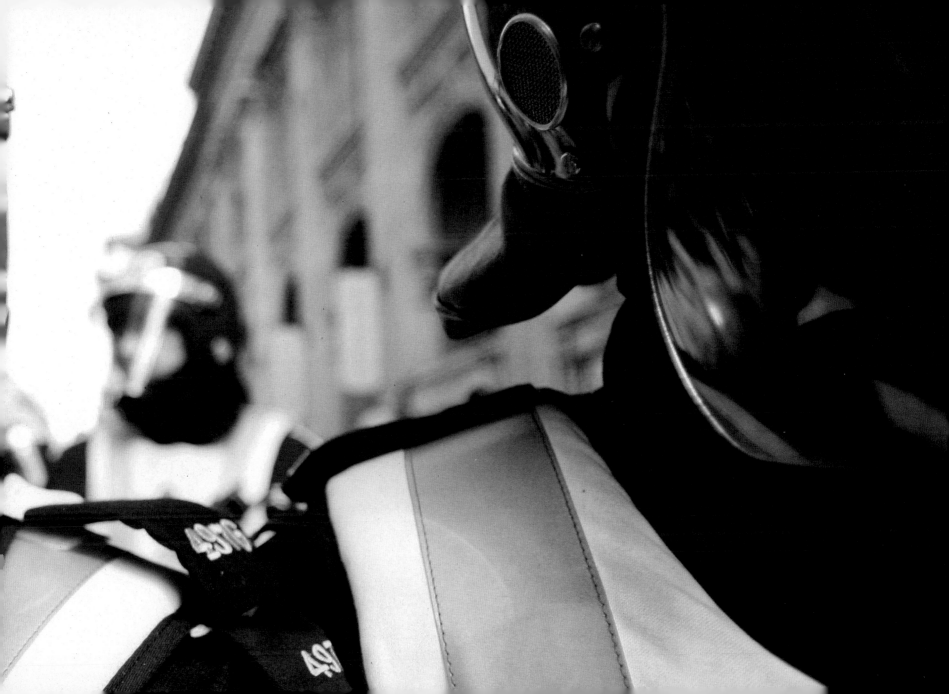

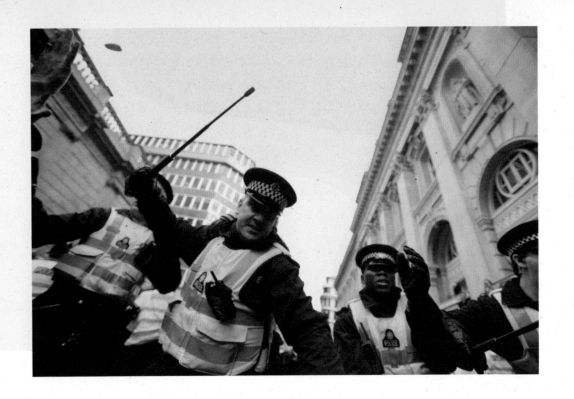

As a symbolic statement the windows of the Royal Bank of Scotland were smashed. The RBS came under attack as, despite being bailed out by £20 billion of tax-payers money, it was still paying out millions in bonuses. Many people were furious that former CEO Sir Fred Goodwin still stood to receive a pension of £703,000 a year, despite presiding over the worse banking collapse of our generation.

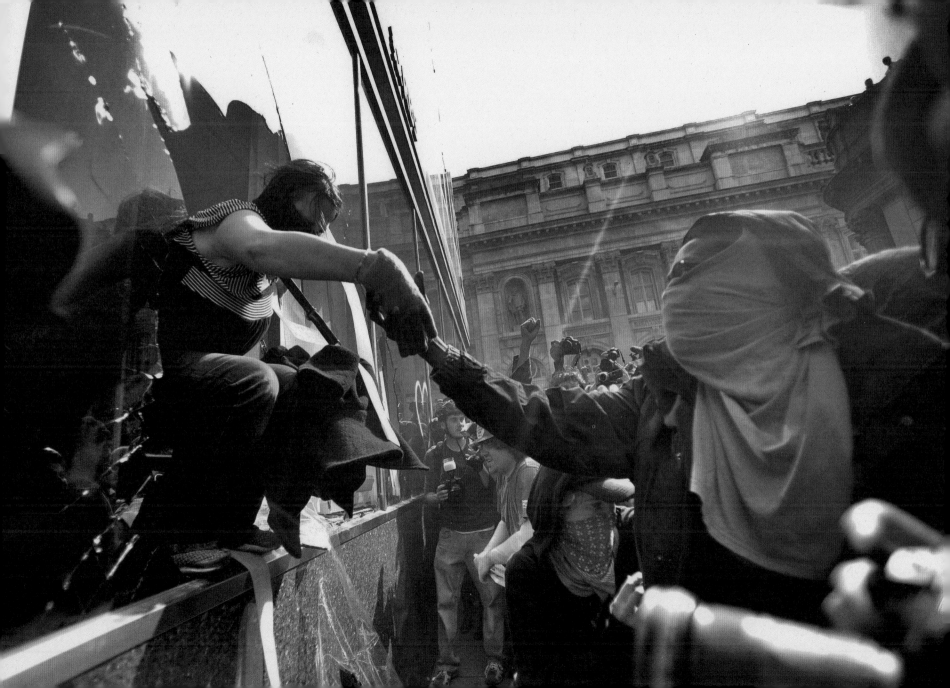

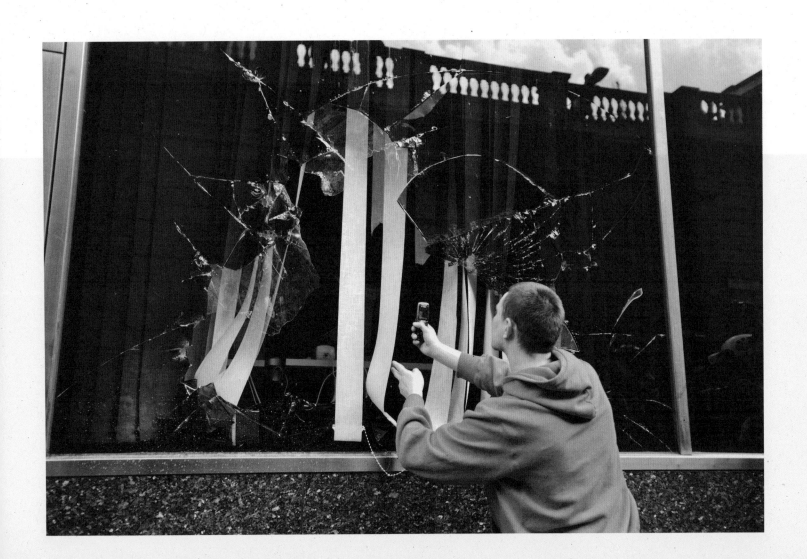

WHAT IS THIS?

WE SMASH 3 WINDOWS AND GO HOME.

IS THAT IT? IF THIS WAS ATHENS

CARS WOULD BE ON FIRE BY NOW.

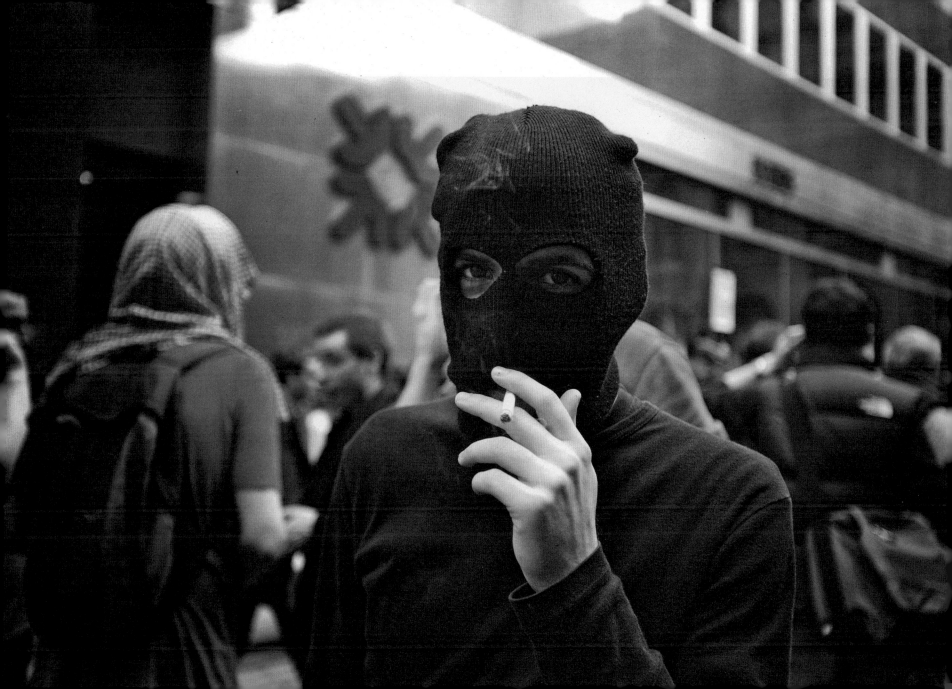

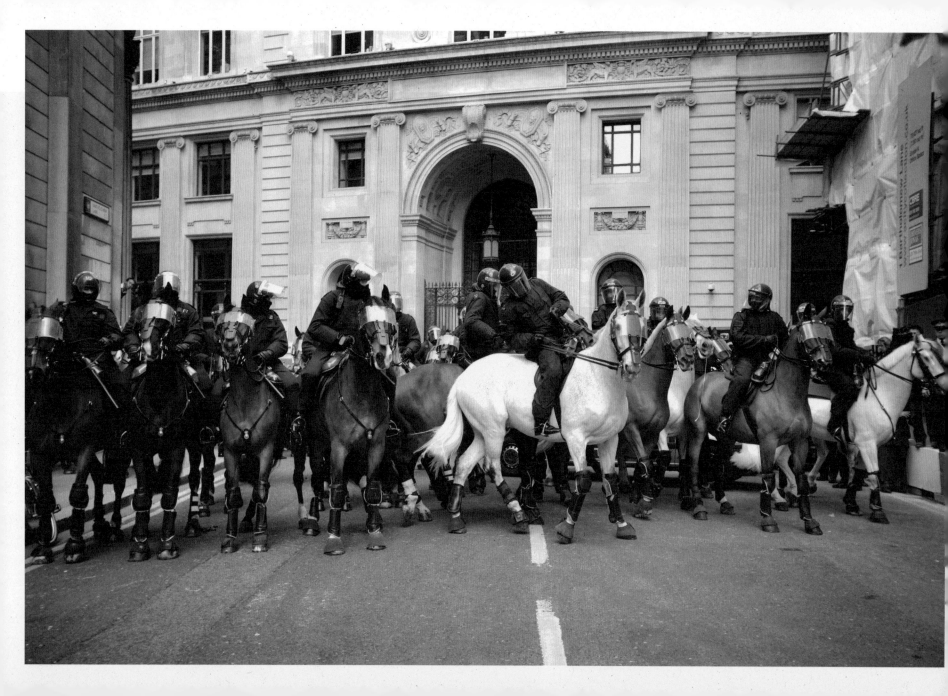

To control the protests police used the controversial technique called 'kettling' to seal surrounding streets and not let anyone in or out. This led to further clashes with police as people tried to force their way out. Even the horses were in riot gear.

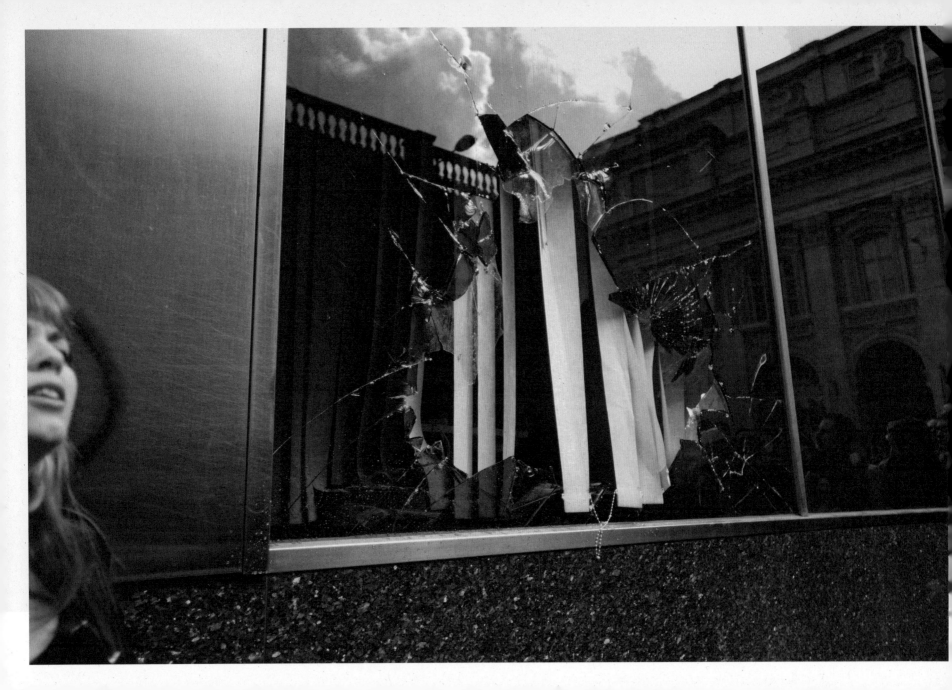

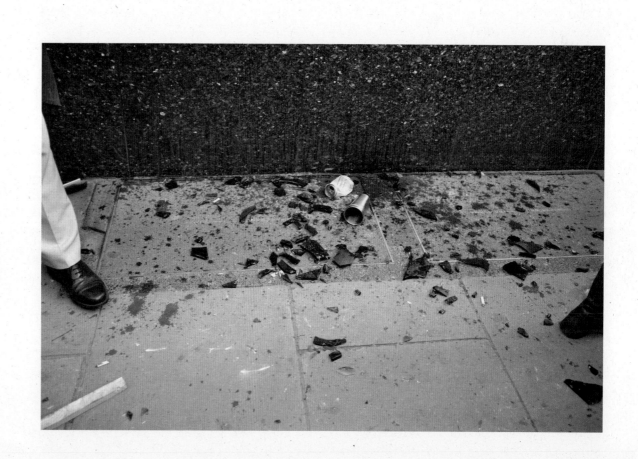

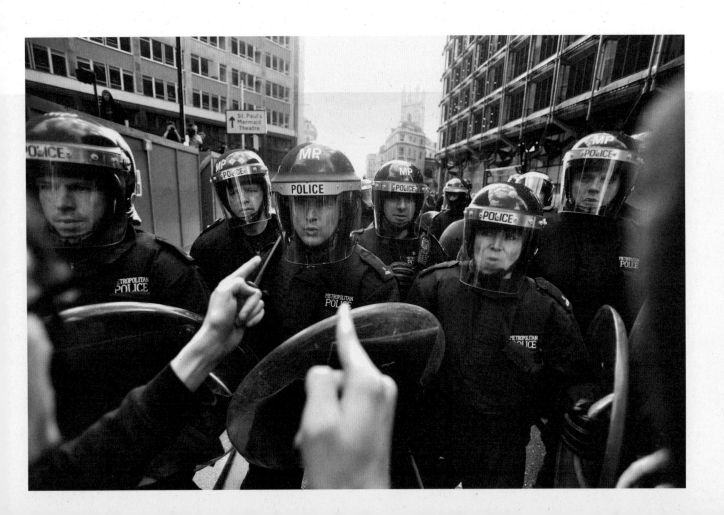

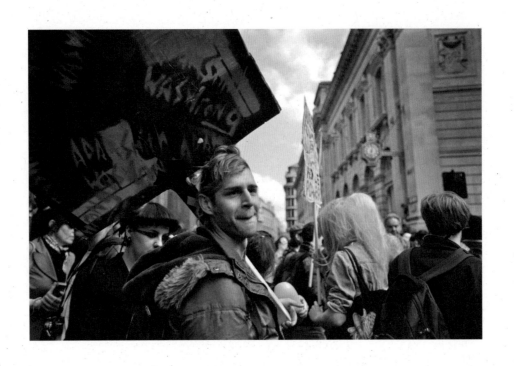

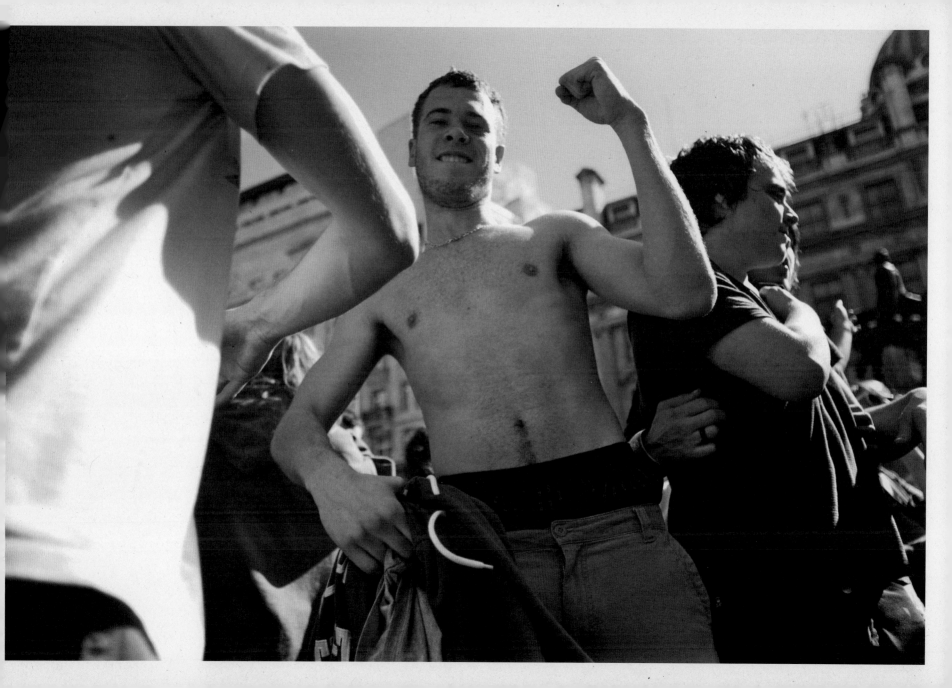

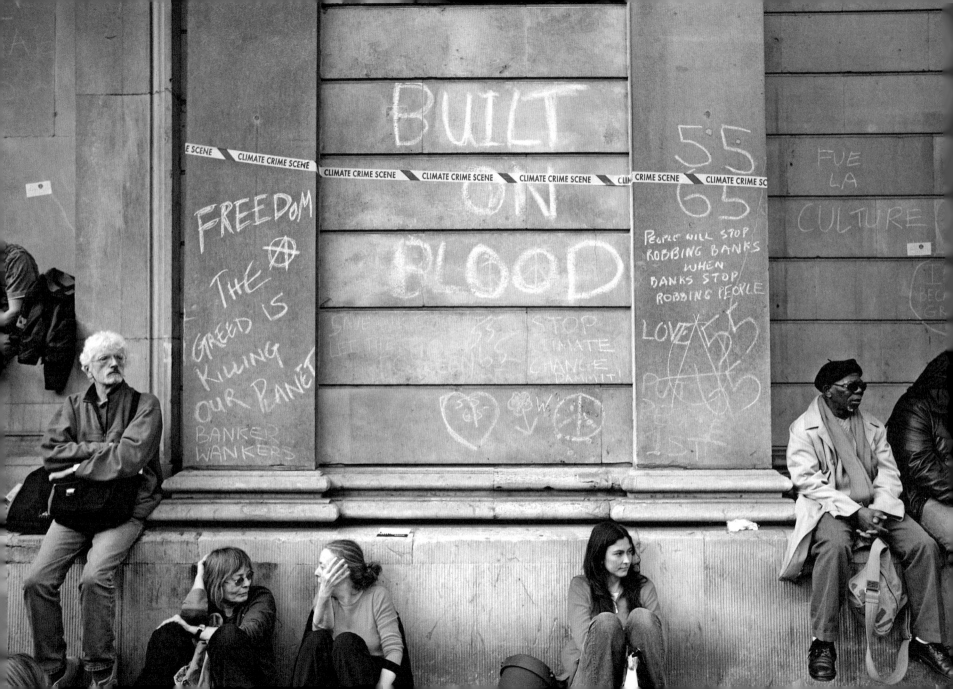

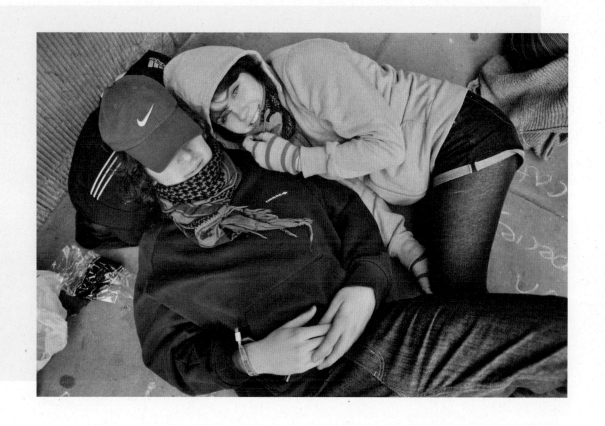

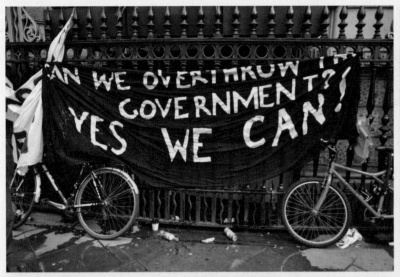
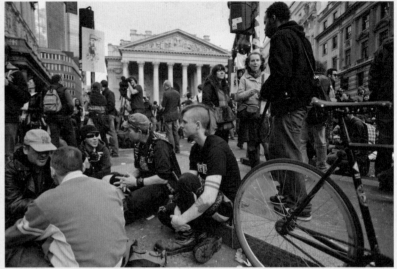
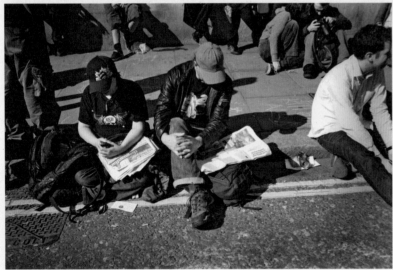
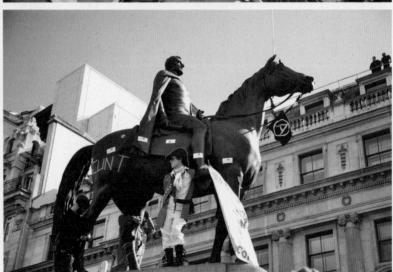

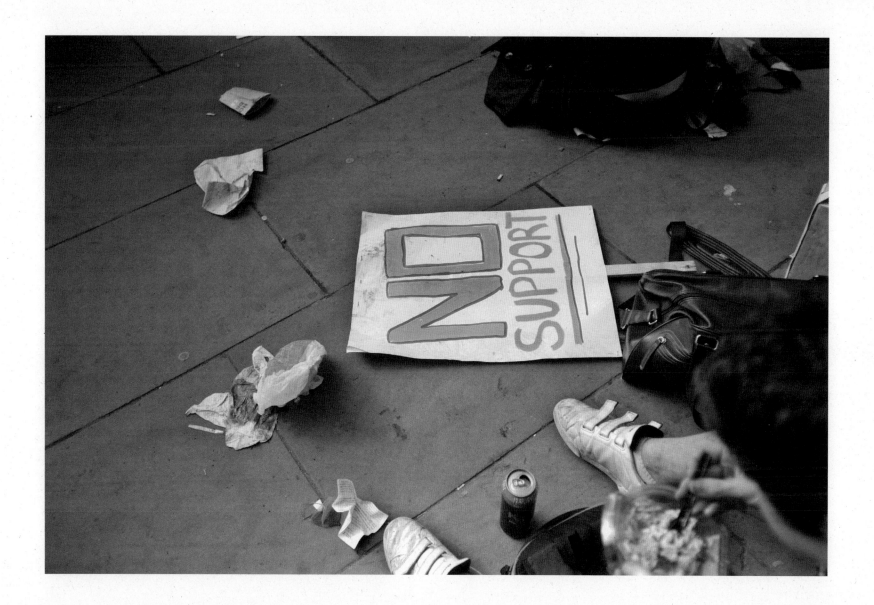

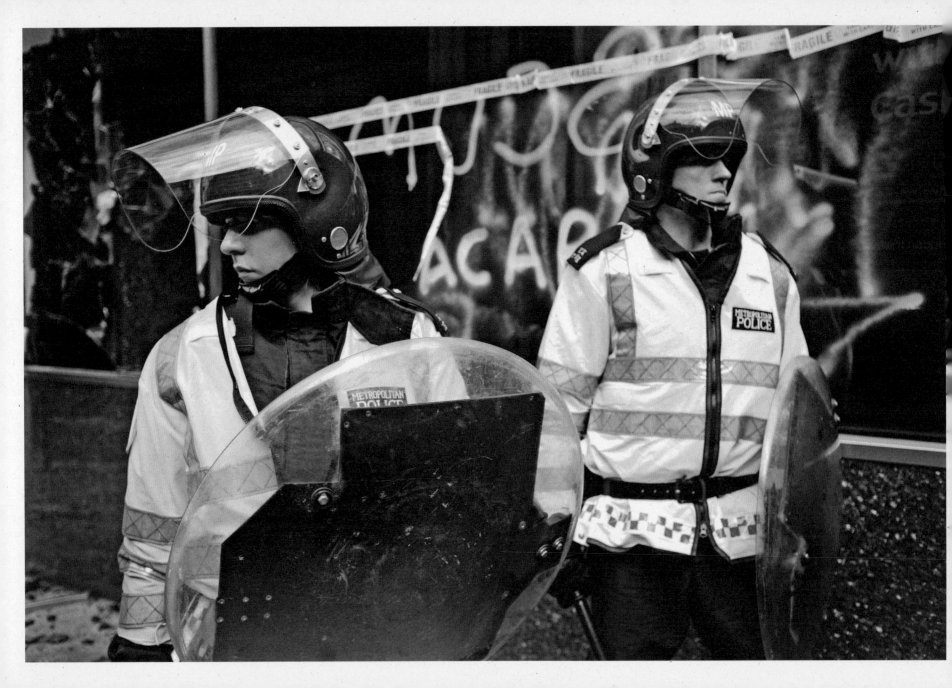

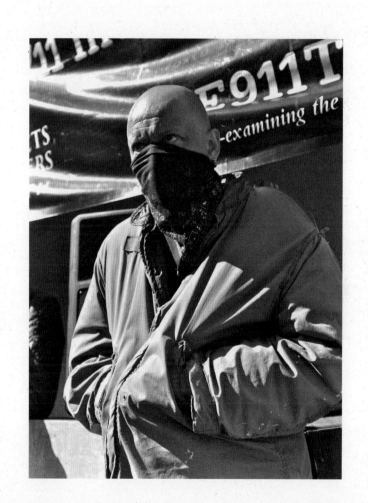

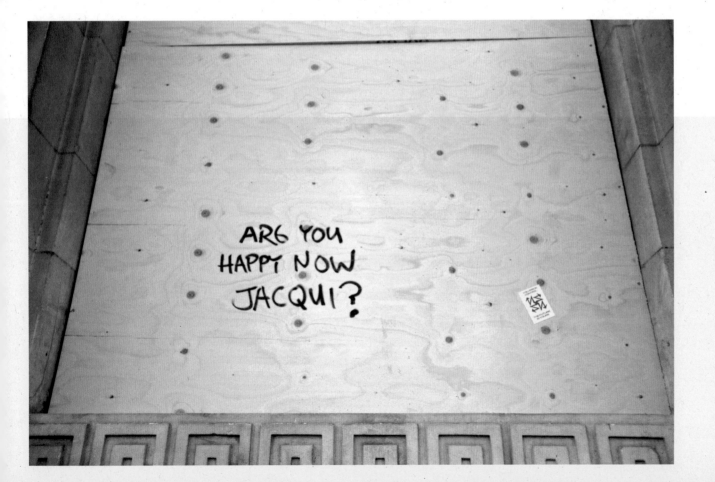

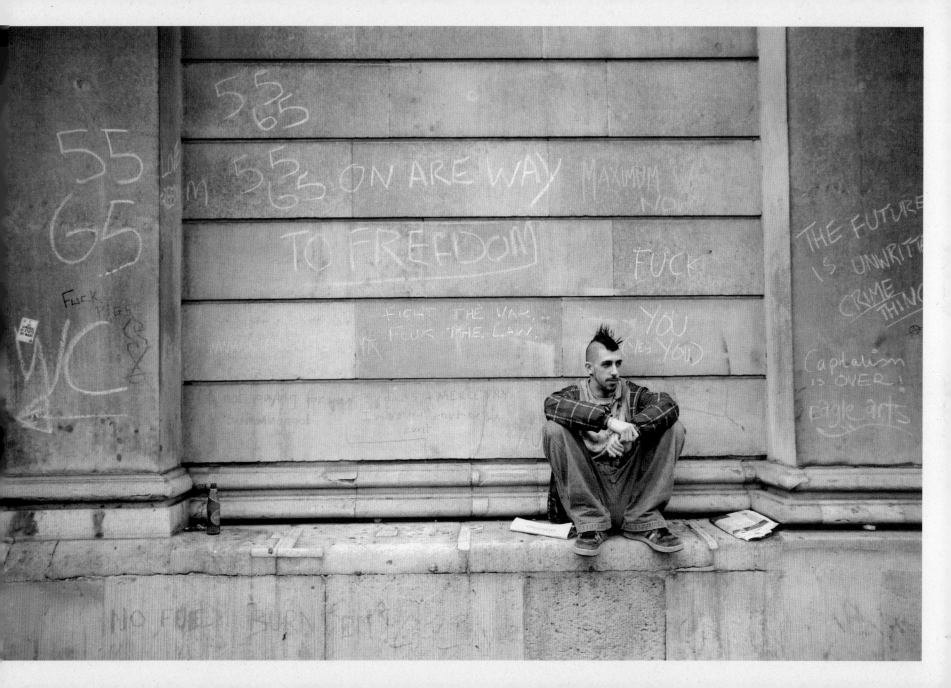

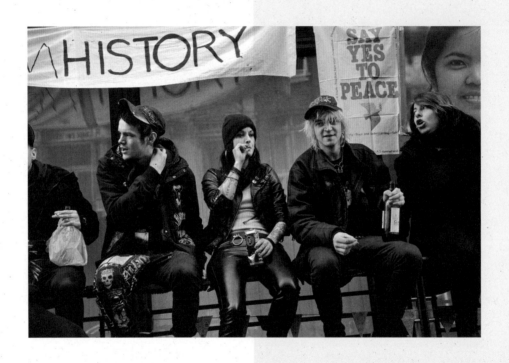

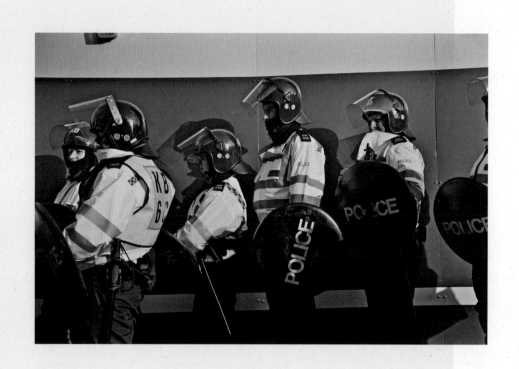

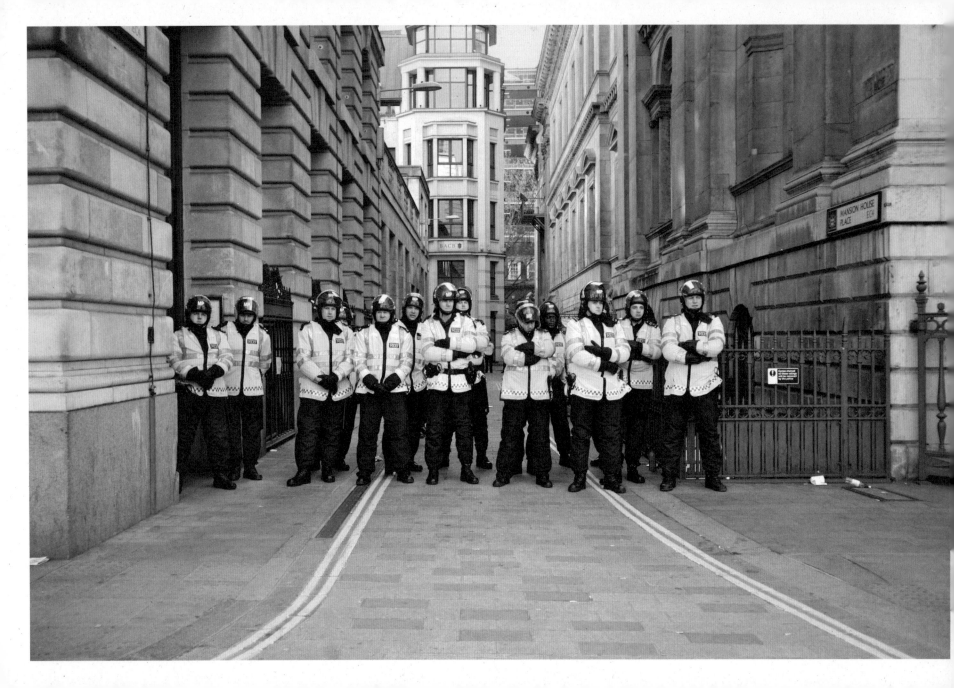

the people

reclaimed

these
streets

THE SUMMER OF RAGE?

The hysterical build-up to the G20 in London threw up many questions about media responsibility.

A lot of the mainstream media coverage seemed to ignore what the G20 was actually about such as the $1.1 trillion aid package agreed for the IMF. Instead it revolved around Barack Obama, his car, smiles, handshakes, what Michelle Obama was wearing or footage of violent clashes between protesters and police.

To me, the media prediction of 'meltdown in the city' became a self-fulling prophesy. In our instant 24-hour news culture many journalists reported live via twitter or mobile phones from the heart of the action and, in a way, media expectations seemed to fuel the violence.

The G20 protests intended to bring issues such as the credit crunch and climate crisis to the forefront of the media agenda but despite the fact that most protests were peaceful, many felt the meaning was diluted by violent clashes with police.

The smashing of the RBS windows was symbolic but anyone can smash a window to get attention. When you have the world's attention you better have something good to say.

'The Summer of rage'? Looking out the window in Canary Wharf my friend Gian would say 'don't believe the hype'.

You decide for yourself.

PS. GIAN GETS A SHOUT-OUT

2010 © Jane Stockdale,
author(s) & Koenig Books, London

Designed by Adam Rix & Jane Stockdale

Illustration by Anje Jager

Production by Plitt
Printmanagement, Oberhausen

First published by Koenig Books London

Koenig Books Ltd
At the Serpentine Gallery
Kensington Gardens
London W2 3XA

www.koenigbooks.co.uk

Printed in Germany

ISBN 978-3-86560-813-0

Distribution:

Buchhandlung Walther König, Köln
Ehrenstr. 4, 50672 Köln
T: +49 (0) 221 / 20 59 6 53
F: +49 (0) 221 / 20 59 6 60
verlag@buchhandlung-walther-koenig.de

Schweiz / Switzerland
Buch 2000
c/o AVA Verlagsauslieferungen AG
Centralweg 16
CH-8910 Affoltern a.A.
T: +41 (44) 762 42 00
F: +41 (44) 762 42 10
a.koll@ava.ch

UK & Eire
Cornerhouse Publications
70 Oxford Street
GB-Manchester M1 5NH
T: +44 (0) 161 200 15 03
F: +44 (0) 161 200 15 04
publications@cornerhouse.org

Outside Europe
D.A.P. / Distributed Art Publishers Inc.
155 6th Avenue, 2nd Floor
USA-New York, NY 10013
T +1 (0) 212 627 1999
F +1 (0) 212 627 9484
www.artbook.com

Big thanks to Franz Koenig, Akiko and Thomas from Lodown, Corinna Koch, Adam Rix,
Anje Jager, Mischa Gayring, Sönke Thormählen, my Mum & Dad, Dave the Rave, Alex + Eli,
Ryo, Johnny Z, Mr GPA, Mike, Cass, Ira the Don, Kris, Geert, Irene, Doco, Rachie, Pammy,
Wally, Costa, Jimmy, Pete, Sam, Wes, Jon Burden, G-Cat, Naoms, Viv, Ash, Sean, Mrs H and ET.
In memory of Elliot Simms. Thanks to everyone at the G20 protests, hope you like this book.
Banchory Forever. All rights reserved. All wrongs reversed.